the

DOODLE circle

the DOODLE circle

A Fill-In Journal for BFFs to Share

Dawn DeVries Sokol

Amulet Books

STC Craft | A Melanie Falick Book
Stewart, Tabori + Chang | New York

Library of Congress Cataloging-in-Publication Data

Sokol, Dawn DeVries.
 The doodle circle : a fill-in journal for BFFs to share / Dawn DeVries Sokol.
 pages cm
 ISBN 978-1-61769-053-2
1. Handicraft—Juvenile literature. 2. Arts—Juvenile literature. 3. Doodles—Juvenile literature. 4. Creative activities and seat work—Juvenile literature. 5. Girls—Social networks—Juvenile literature. I. Title.
 TT171.S65 2013
 745.5—dc23

2012051160

Editor: Liana Allday
Designer: Dawn DeVries Sokol
Production Manager: Alison Gervais

Printed and bound in the United States
10 9 8 7 6 5 4 3

Amulet Books are available at special discounts when purchased in quantity for premiums and promotions as well as fundraising or educational use. Special editions can also be created to specification. For details, contact specialsales@abramsbooks.com or the address below.

ABRAMS
THE ART OF BOOKS SINCE 1949

115 West 18th Street
New York, NY 10011
www.abramsbooks.com

this BOOK BELONGS to:

(Make sure to include a phone number or e-mail address!)

To all members of the circle: By signing your name in this circle, you pledge to not share the contents of this book with anyone outside of your circle. You are forming a pact with your circle sisters. Add some doodles next to your signature and make it pretty!

Contents

intro

WHAT is a ROUND ROBIN?

A "round-robin" is not a restaurant or the name of a band. OK, it COULD be a band. But for this book's purposes, a round-robin is essentially a journal that is passed around from person to person, filled in by everyone, and returned to the book's owner once the pages are filled. I like to think of it as a "traveling journal," and what you wind up with at the end is a memento like no other.

THE DOODLE CIRCLE is a way for you and your friends to share your lives and celebrate your friendships, and it will eventually contain doodles, notes, and photos from your most cherished times together.

Your group of friends might include three people, five, seven, whatever. No worries about how many are in your group! If your circle grows or changes during the time you're working on THE DOODLE CIRCLE, no worries about that, either. It's easy to include new friends at any point. The way to make the most of this journal is for each person to have a copy and pass it around the group. That way everybody gets to have a treasure to keep.

DUCtiON

HOW to USE this BOOK

While there are no rules in art journaling, these guidelines
will help you make THE DOODLE CIRCLE a fun project! Try
to be honest, but stay positive as well. And be sure to leave
plenty of room on the pages for your circle sisters' responses.

1. Make sure to fill out the owner's info on page 5, and ask
 your friends to sign their names on that page as well.

2. Read "Supplies You'll Need" on page 12, and use any
 pens, markers, pencils, or art supplies that make you
 feel comfortable, confident, and creative. Also, you might
 want to photocopy some of your photos with your
 friends so that you can cut them up and use them for
 collage. And make sure to have some special doodads
 and souvenirs on hand for collage, such as favorite
 candy wrappers, notes you've sent to each other,
 ticket stubs, and other flat paper items you can glue
 down in the book.

③ The prompts or exercises in Chapter 1 are to be answered by each friend about herself. So in that chapter, you will each doodle, write, and collage about yourselves.

④ In Chapter 2, ONLY the owner of the book will write, doodle, and collage about herself. These pages are hers alone to fill in.

⑤ In Chapter 3, each friend will doodle, write, and collage about the owner of the book.

⑥ In Chapter 4, you will all work together to doodle group masterpieces.

⑦ The "blank" pages sprinkled throughout the book are for you to start whatever "conversation" you may want to have with your friends or to continue a project from another page.

(8) Remember that this is collaborative art. Others may draw or write over something that you put on a page. That's part of the process. Keep an open mind and have fun creating something special with your circle.

(9) When you doodle, collage, or write, make sure you are respectful of everyone else's feelings. This is all in the spirit of friendship and is meant to strengthen and seal your bond with the others in your circle.

(10) HAVE FUN!

SUPPLIES you'll NEED

The most important tool you'll need for this book is a pen—one you really like. Here are a few types of pens and other tools you might like, too.

PENS

BLACK FINE-TIP PENS

I prefer Sakura Micron pens because they don't fade, they're waterproof, and they have different-size tips. For thicker lines, use the 08 (0.50 mm). If you want thinner lines, they make tips as small as 0.20 mm (size 005). These are available at craft stores and art supply stores.

Ballpoint pens are fine, too!

GEL PENS

Any Sakura gel pen will work well. The Glaze pens are more translucent and are jewel-toned, whereas the Soufflé pens are pastel and not as shiny when the ink dries. Both are available at craft stores. Sakura has other gel pens, too, such as Gelly Roll Moonlights (which are neon!), Gelly Roll Stardust (which are glittery), and Gelly Roll Metallic. Use these to color in your doodles.

markers

Sharpie's Poster-Paint Markers are perfect for doodling AND coloring and are available in lots of colors and tip sizes. Make sure to get the water-based kind. You can find them in office supply stores, craft stores, and art supply stores.

Crayola Pip-Squeaks Markers are a fun, inexpensive option and easy to carry with you. They come in many colors and are widely available.

PENCILS

NO. 2 PENCIL

Try your best NOT to use the eraser! Doodling is a free-flowing form of mark-making, and erasing just interrupts that flow.

COLORED PENCILS

Use any kind!

attachments

ADHESIVES

GLUE STICK

GLUE STICKS

UHU Stic or Elmer's Glue Sticks work well and are a less messy option than regular glue. Both can be found in craft stores.

TOMBOW MONO ADHESIVE

My personal favorite for gluing bits of collage is Tombow MONO Adhesive, which can be found at craft stores. The adhesive is applied by a tape roller, and it's easy to take with you for moments of sudden inspiration.

OTHER WAYS TO ATTACH PHOTOS AND ITEMS

PAPER CLIPS

An easy, no-mess way to attach photos and collage bits to the edges of pages.

PHOTO CORNERS

A pretty, decorative way to include a photo in your book.

STICKERS

Use any kind of sticker to add a word or an extra visual; you can also use a sticker to attach collage bits to the page.

TAPES

Masking tape, Scotch tape, and washi tape are all great for attaching photos and bits of collage to the page.

SCISSORS

It's always good to have a pair of tiny scissors on hand for cutting people and shapes out of photos or magazine pages. The tiny size makes it easy to cut out small items.

COLLAGE bits

Throughout this book, I mention using collage bits. You might want to have some color-copied photos, notes, candy wrappers, or other small mementos on hand. Pieces of fabric, pretty wrapping papers, ribbons, buttons, or sequins (as long as they lay flat) are also cool to use.

My Circle Sisters

chapter (1)

In this section, EACH circle sister will contribute to every single page.

guidelines

(1) Answer ONLY about yourself on each page in this section — let each of your circle sisters speak for herself.

(2) Be as honest as possible but stay positive. It's OK if your answers are different in each book, as your ideas may change as you go.

(3) Make sure to leave room on each page for everyone in the circle to answer about herself.

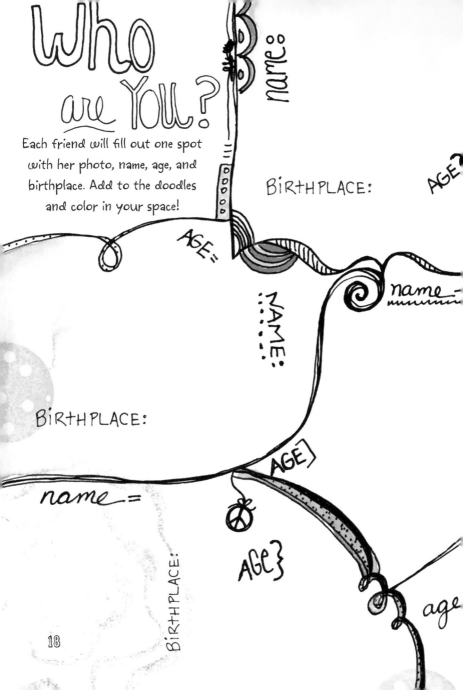

Who are You?

Each friend will fill out one spot with her photo, name, age, and birthplace. Add to the doodles and color in your space!

name:

BIRTHPLACE:

AGE?

AGE=

name=

NAME:

BIRTHPLACE:

AGE]

name=

AGE}

BIRTHPLACE:

age

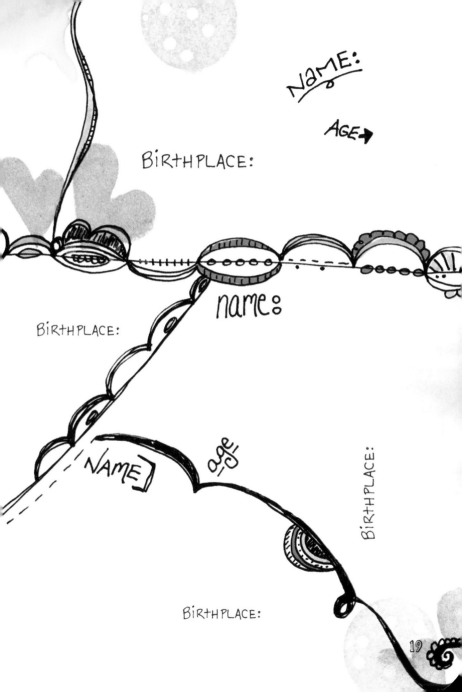

NAME:

AGE ➤

BIRTHPLACE:

name:

BIRTHPLACE:

NAME]

age

BIRTHPLACE:

BIRTHPLACE:

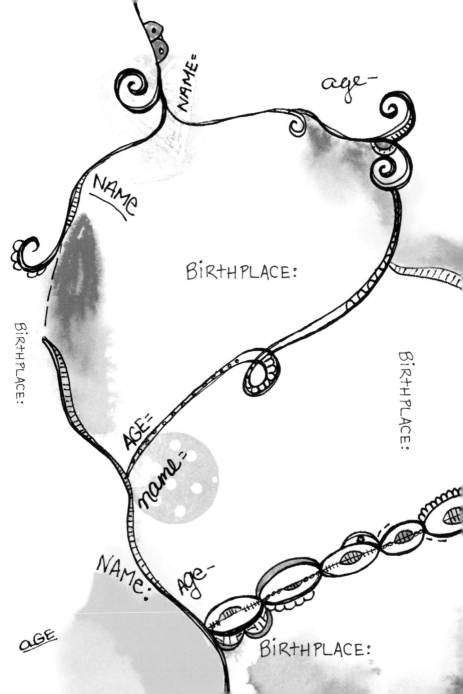

NAME:

BIRTHPLACE:

age

BIRTHPLACE:

name →

BIRTHPLACE:

age:

NAME:

BIRTHPLACE:

age:

21

YOUR CIRCLE

SYMBOL

Doodle a symbol or two somewhere on this page that you love or that personifies you. This symbol or symbols will represent you in THE DOODLE CIRCLE.

tip:

Symbols such as hearts, peace signs, flowers, and stars are easy and can be doodled in many different ways. You can make them simple or intricate, depending on how you're feeling at the time!

23

Activity Circle

What are your main interests?
What activities do you like to participate in?

25

WORD!

Your favorite word or phrase:

tip:

You can write/doodle a word or find it in a magazine, cut it out, and paste it down. Be sure to doodle over it and make it your own!

TRUE COLORS

What color best represents you? Why?

Use a marker in that color
to doodle and then write
about how the color
expresses who you are.

MARKER

What are your fave songs right now?
Fave musicians? Singers? Bands?

DOOdlE a diTTY

31

tHE SeCReT CiRCLE

What is one secret about yourself that you're willing to share with your circle sisters? Write or doodle it in a section of the circle. (Each girl HAS to swear it stays in this book!)

33

chapter

All About Me

Only the book's owner should answer the prompts in this section.

GUIDELINES

① These pages are for you to work on alone.

② Be as honest as possible.

③ It's all about you! Take up the whole page with doodles, since you aren't sharing space with your friends.

dREAMViLLe

What is a crazy dream you had recently?
Try to doodle it out.

RiGH HOPES

What do you hope for in life?

39

ME, MORTIFIED

What was your most embarrassing moment?
What would you do differently if you could?

looking up

Name three people you look up to or want to be like. If you can, paste down their photos. Why do you want to be like them?

45

Doodle it, write it, or collage it!

What do you think makes life awesome? It can be something little or something big.

If you could change your name to anything else, what would
it be and why? Doodle it out here and make it look fancy!

What's in a NAME?

TIP:
Bubble letters are always a simple way to doodle a word. You can even fill in the letters with little doodles and collage.

Doodle yourself wearing your favorite outfit on this page (or doodle yourself wearing an outfit you want!).

What outrageous outfit would you love to wear
if you could? Find a photo of your fantasy outfit
in a magazine or online and paste it down.

PET PEEVES

What bugs you?

PERFECT

What makes you smile? PLEASURES

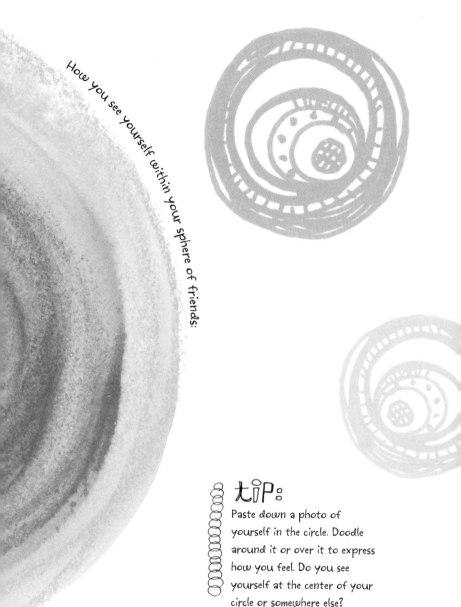

How you see yourself within your sphere of friends:

TiP:

Paste down a photo of yourself in the circle. Doodle around it or over it to express how you feel. Do you see yourself at the center of your circle or somewhere else?

your chapter ③ Spot in the Circle

Let's celebrate YOU: the owner of this book. On these pages, the other girls in your circle will doodle, write, and collage about what makes you and your friendship special.

guidelines

① Answer in this section ONLY about the owner of this book. Be kind and make her feel like the awesome person she is!

② Make sure to leave room on each page for the other friends in the circle to answer, too.

③ The owner of this book is not to write anything in this section.

first impressions

How did you meet _____,
(insert name)
and what did you think of her at first?

The sweetest thing _____ has ever done for you:
(insert name)

WHAT
have YOU
donE FOR
ME lately?

Why is _____ a good friend?
(insert name)

What do you appreciate most about _____?

(insert name)

good times

The most fun you've ever had with _____ is:
(insert name)

in the loop

What is one special thing that _____
 (insert name)
brings to your circle of friends?

in LiViNg color

What color represents _____ and why?

(insert name)

Remember, many different colors can represent one person. And there's no right answer, so don't worry about how your "sisters" answer!

ch-ch-changes

How has being friends with _____ changed you?
(insert name)

80

81

CRYSTAL BALL

In the future, _____ is most likely to be:

(insert name)

SEParAtED at bIRtH

_____ looks most like _____.
(insert name) (what famous person)

Glue her photo above, and glue photos of
famous people in the frames on the opposite page.

85

My Wish

for YOU

What do you want for _____?
 (insert name)

fASHiOn

What piece of _____'s clothing would you most like to borrow?
(insert name)

Passion

INSIDE JOKES

What is a private joke or a hilarious moment you've shared with _____?
(insert name)

Share it here, especially if your other "sisters" haven't heard it yet.

Fun fact

Name one fun thing about _____
 (insert name)

that makes her HER. Doodle, collage, or write it!

don't forget

List, doodle, and/or collage
things that you don't want

_ _ _ _ _ _ _ _ _ _ _ _ _ _

to ever forget (like little random
moments of your friendship).

take back

What is something you've said to _ _ _ _ _ _ _ _ _ _ _ _
(insert name)

that you'd like to take back?

Do so here! Write it and then scratch it out or collage and doodle over it. Then write what you wish you had said instead.

chapter ④

The Whole Circle

In this chapter, all the friends in your circle will work together to add on to each other's doodles, words, and collages. This is a great section to work on while you're all together at a sleepover or hanging out after school.

guidelines

① ALTER WITH LOVE. If you want to change something someone else has doodled or written, do so carefully. Make it a positive change and something that your "sister" will appreciate.

② Make sure to leave room for the other girls to contribute.

Map Makers

Draw a map of your stomping grounds. This can be a map of your city, highlighting where each of you live and the places you hang out, or a map of a school, camp, or sports center you attend together. Whatever you like!

tiP:
Use bits of patterned
paper to distinguish
special spots on the map.

circle DOODLE

Each friend should contribute some doodling to this page, picking up where the last friend left off. (There's a starting doodle below, if you want to use that.) You might want to add collage and doodle around that, too.

Doodle or write a random word that pops into your head. If your friends have already written words, what do their words make you think of when you read them? Add to them!

POETRY

CiRCLE FiLM

What are your group's favorite movies? List them here. Once you've named your faves, have a "Circle Film Fest" and watch them all!

FESTIVAL

Doodle over and around these splotches, and then
add on to your friends' doodles.

A bird sits atop a tree in the middle of a city.

Doodle the scene described above anywhere on this page. Once you are done, tape a piece of paper over your drawing so no one else can see it. When each girl has doodled her "vision," remove all the papers to see how differently everyone doodled the same scene.

List LOOP

Use collage to create lists with your friends on these pages.

i like :

8 eat:

I CARE ABOUT:

i don't:

nondomiNANt
DOODlE

No cheating on this one! No matter how much you hate the results, use your nondominant hand only.

Doodle on these pages with your nondominant hand. Try to add on to what your friends have already marked on these pages.

DESIGNING JEWELRY

Doodle a piece of jewelry
that you would like to
wear, or start a piece that
your "sisters" will add on
to. Work together to doodle
or collage a jewelry set.

List your favorite
quote or quotes.

WorDS of

WISDOM

tip:
Use a combination of words, collage bits, and doodles to add a fun spin on this.

Doodle symbols that represent words on this page. They can stand for a place, person, or even a mood (such as a heart for love and a smiley face for happiness). Use these symbols to create your own doodled language with your circle sisters.

Tape or glue a flat item — such as a ticket stub, a piece of ribbon, or a receipt — that each circle sister "found" this week. Doodle and write around the items, and try to link them together with doodles.

WHAT WE FOUND

Doodle or collage something on this page that scares you or that symbolizes a fear for you. Once everyone in the circle has done this, go back and doodle or collage over your friends' fears to make them into something less scary.

fEAr FactoR

doODLE DROP

Doodle, write, or collage something here that you need to get off your chest. Everyone can add to or doodle over each other's "spillage."

143

List songs that you and your circle sisters love to listen to together.

the CIRCLE
PLAYLiST

tiP:
When you're done,
make a playlist you
can all listen to!

group gallery

Doodle over these shapes to make them look like picture frames hanging on a wall, then paste your photo into one of the "frames."

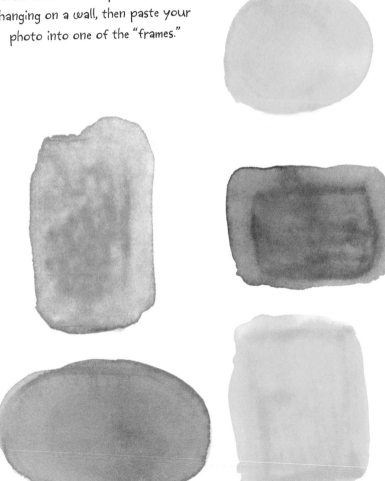

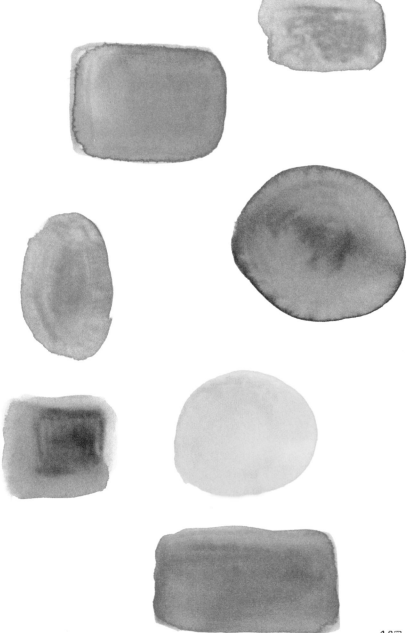

DOOdlE DiCTiOnaRy

Write and doodle words that
are popular in your circle (like slang
words, phrases, and expressions),
along with their definitions.

circle time CAPSULE

What would you like to put into a time capsule for your "sisters"? Draw the objects here.

THE Sister scene

Get a photo of all of you together, cut the
group out, and paste just that part down
on the page. Work together to doodle
a background scene. Maybe you're in a
futuristic city? Or maybe you're hanging
out with the animals at the zoo? Or maybe
you've all just climbed Mount Everest!

tiP:
If you don't have
a group photo, no
worries. Just use
individual photos
of each friend.

We're all imperfect. Write or doodle about a thing you did or said when you weren't at your best. Make a pact with your friends to do better next time.

WHAT MY CIRCLE means to ME

Tell your circle sisters what
their friendship means to
you and how they make
your life awesome.

♡ LOVE and thanks ❀

To my family, especially my husband, T.J., and my mother; to my agent, Jean Sagendorph Pocker; to my editor, Liana Allday; to the entire crew at Abrams; to my blog readers and students, for without them I wouldn't be able to do what I'm doing; to my faithful dog, Lucy, for pushing me to get out of the studio once in a while and listening to me blather on when no one else is around; and to my circle of friends, who cheer me on and are always there for me when I need them, no matter how many miles separate us.

about the AUTHOR

Dawn DeVries Sokol is the author of several art journaling and doodling books, including ART DOODLE LOVE, DOODLE DIARY, DOODLE SKETCHBOOK, and 1,000 ARTIST JOURNAL PAGES. She journals and doodles in her Tempe, Arizona, studio and hopes to one day get over her fear of the large canvas.